BERYL COOK

The Works

BERYL
COOK

The Works

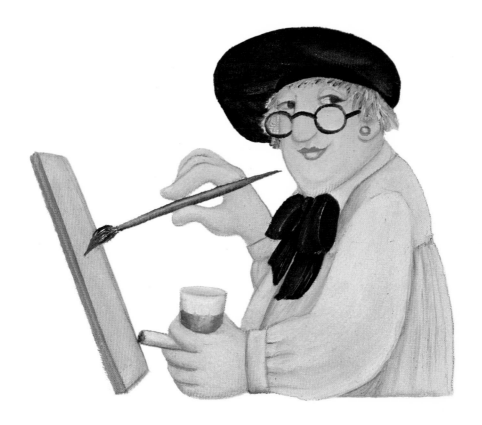

John Murray
Gallery Five

© Beryl Cook 1978

First published 1978 by
John Murray (Publishers) Ltd
and Gallery Five Ltd, 14 Ogle Street, London W1

Printed in Great Britain by
Jarrold and Sons Limited, Norwich

0 7195 3556 5

Thanks to my Friends

I did my first painting in Rhodesia some years ago. I had been showing my son John how to use his paint-box and found I was enjoying it far more than he was. My husband John then bought me an oil-painting set and one small painting appeared: hardly a Raphael but somehow satisfactory. I didn't do any more until we returned to England about twelve years ago and went to live in Looe; I started again, and have painted continuously ever since.

Looking back, it seems that it was exactly the right time for me to start. I was happily settled at home, and with my son away at college I had plenty of spare time. There was also the incentive of all the bare walls in our cottage, and the driftwood from the beach provided an ideal material to paint on: it was a most satisfactory arrangement to go down to the shore, collect a piece of driftwood, and then transform it. But soon I was painting compulsively and the supply of driftwood was inadequate. I would paint on anything that came to hand: John would bring me back pieces of wood from his garage and the timber merchant was most generous with his offcuts.

We have been very lucky, living in such lovely places as Looe and now Plymouth where we moved about eight years ago to a small boarding-house. I had to stop painting for about four months each summer when the visitors were here, and in a way this was quite a relief for by this time there were so many paintings it was becoming increasingly difficult to find enough places to stack them. Through all this my family – now including Teresa, my daughter-in-law – have been marvellous, overlooking dust, unmade beds, unwashed dishes and drunken cackles; they even admired the finished pictures. It is because of my family that I am able to paint.

All the same, I often grew despondent when I found that the finished products rarely matched the beautiful visions

I'd had in my mind, and I felt like throwing the paintings away and giving up painting altogether. A great friend to me then – and ever since – has been Tony Martin, who rescued the paintings and encouraged me to keep going. In the summer of 1975 he insisted that he should take some away and sell them, a prospect which made me very nervous. When he came back a few days later and said he had sold ten of them I was stunned. But it was very exciting to know that people liked them sufficiently to buy them, and this immediately produced a whole new batch, even though it was at the height of the holiday season.

Shortly afterwards Bernard Samuels of the Plymouth Arts Centre contacted me and he arranged an exhibition of seventy-five paintings. This was a great success and Allen Saddler took news of it to the *Sunday Times*. I was delighted to hear that they wanted to do an article and that I would see some of my pictures reproduced. With great help from Bernard and the owners of the pictures I was lucky enough to have an exhibition at the Whitechapel Gallery after this and since then I have exhibited with both the Portal Gallery in London and the Alexander in Bristol. All of them have helped and encouraged me in every way.

I like most of all to see as many of my paintings as possible at once, and the greatest pleasure I have had from them is when others go and look and laugh and perhaps feel cheered up. I have often thought that the best way to present a lot of them at once, to as many people as possible, would be in a book, so when Joe Whitlock Blundell of John Murray's asked me if I would like to do one I was absolutely delighted. Since then we have had great fun sorting the pictures out and putting the book together. I have always been reluctant to part with my paintings – some I miss for a long time afterwards – and now, to my great pleasure, I am able to look at them again, whenever I like.

Beryl Cook

The Works

The Lockyer Tavern

This is the first of several pictures I painted of this pub and it was only after many struggles that I actually made the people recognisable. None of these knew I had been busy at home painting them and I was rather nervous about going into the Lockyer after the pictures appeared in the *Sunday Times*: I was not sure how they would feel about it. They didn't mind though, and I was allowed to continue drinking there. Many happy hours were whiled away in here until we were encouraged to take our drinking, dancing and drag parties elsewhere. There were two bars – one of them gay – singing and dancing, talent competitions and pantomime in drag, all performed by the locals and much appreciated by me. I hope my pictures convey some of this pleasure.

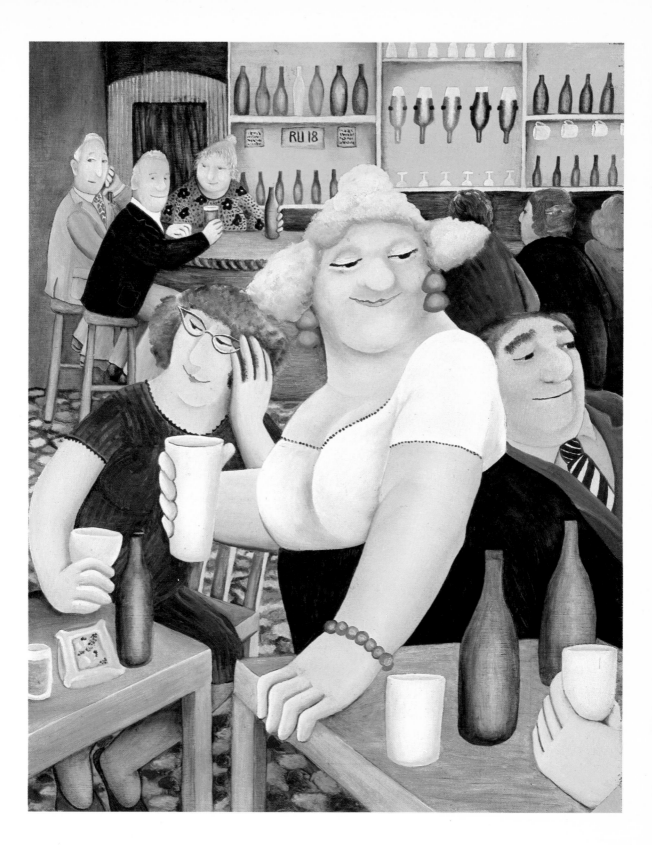

Tom Dancing

Tom, who is wearing the blue suit, was the landlord of the Lockyer at that time, and he used to keep the back bar in some sort of order with great good humour. He didn't often smile, but when Brian picked him up and started whirling him round the room he couldn't resist the fun and a small grin appeared. We are fortunate to live in the very centre of Plymouth, surrounded by lots of lovely pubs, each with different characteristics. This bar had its own special atmosphere and was used as a meeting place for about thirty years, I believe, before closing down last year. I'm glad I was lucky enough to see it in its hey-day.

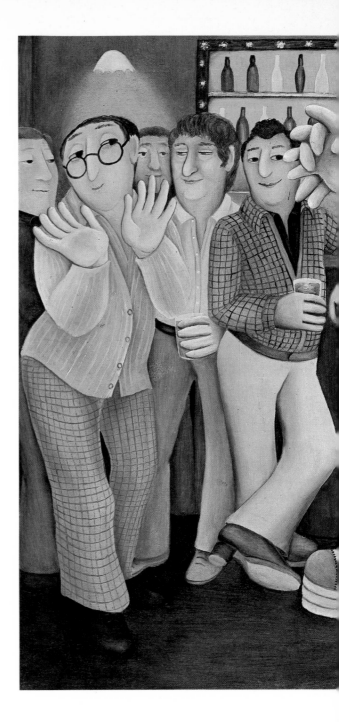

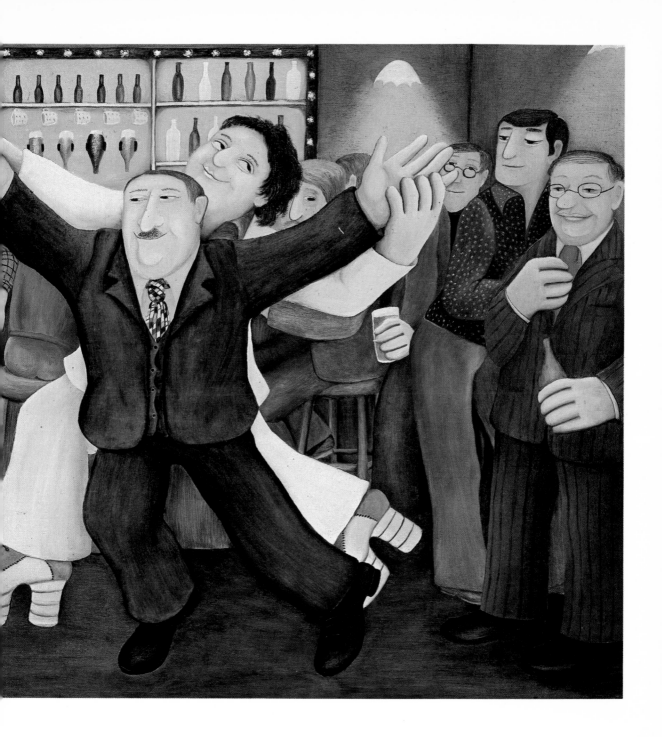

Brian Entertains

It was cabaret night at the Lockyer and Brian was at
his best, dancing away to Len's accompaniment at
the organ and our loud cheers. Suddenly I looked
outside and noticed three men looking in on the
performance. They were doubled up with laughter
and I know just how they felt. Brian's magnificent
headdress deserved real sequins I thought but found
it a bit tricky sticking them on.

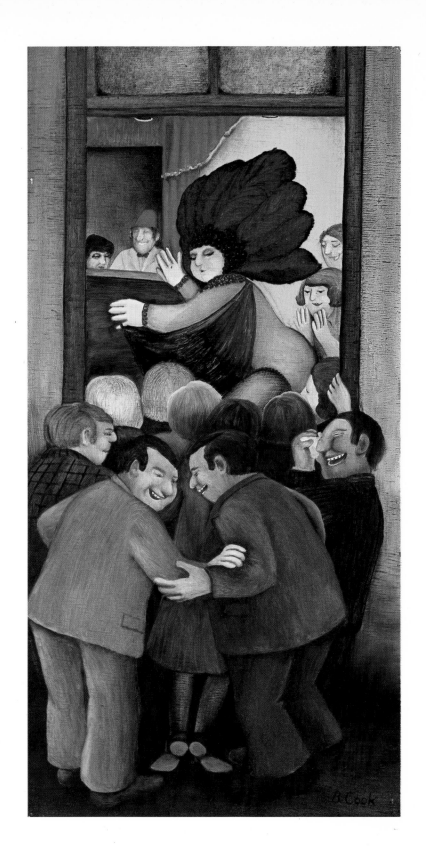

Angela Singing

These girls are part of the gay crowd, great fans of Angela, who used to entertain us in the front bar of the Lockyer on Sunday mornings. There was a very decorative ceiling in here and Frank, who took over as landlord from Tom, used to keep a wary eye on it in case the vibrations from the choral renderings brought it down. I don't think he ever had a dull moment during the year he was in charge, or a peaceful one.

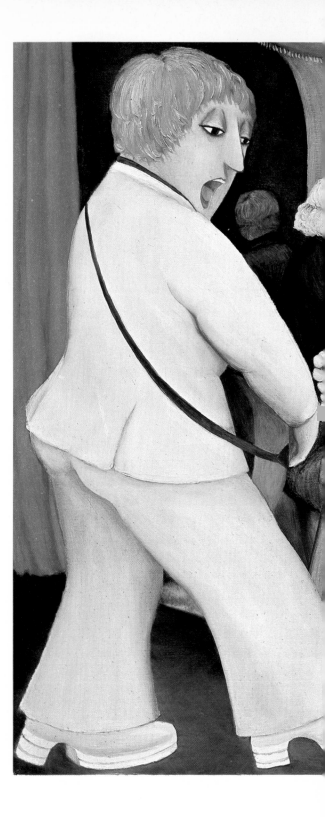

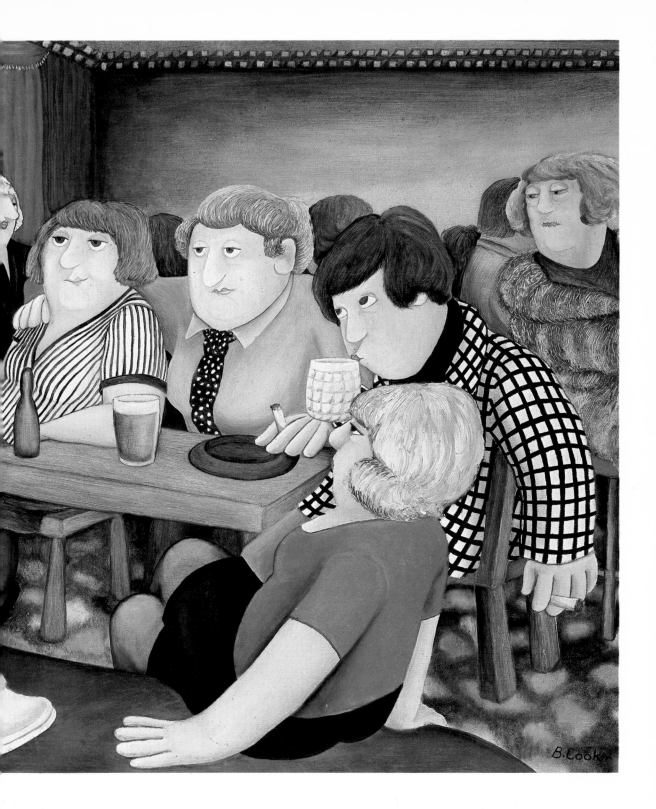

Sylvia

Sylvia used to be a man and is now a lady. Here she is greeting a couple of rather surprised sailors, one having a nicely tattooed arm. I'm very interested in tattooing and have once or twice found it difficult to resist having one myself. But is this in keeping with my image as a gentlewoman I ask myself?

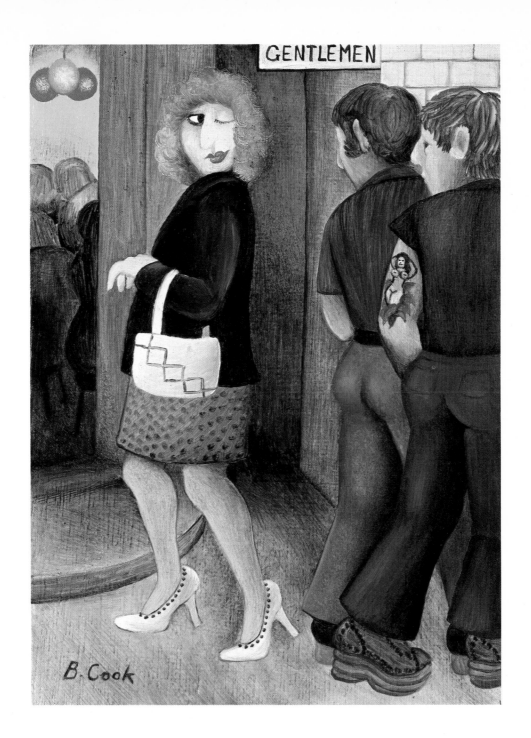

Handel & Liszt

We stopped to let these two pass; she rather
unsteadily, and he most solicitous, and I drew them
as soon as we got home. I was very disappointed
with my attempts to get the tiles in perspective. How
do other painters do it? I know they should be big at
the front and small at the back but they still haven't
come out right. Strangely enough I have been asked
for advice on how to paint, and I hope one day to be
able to give it.

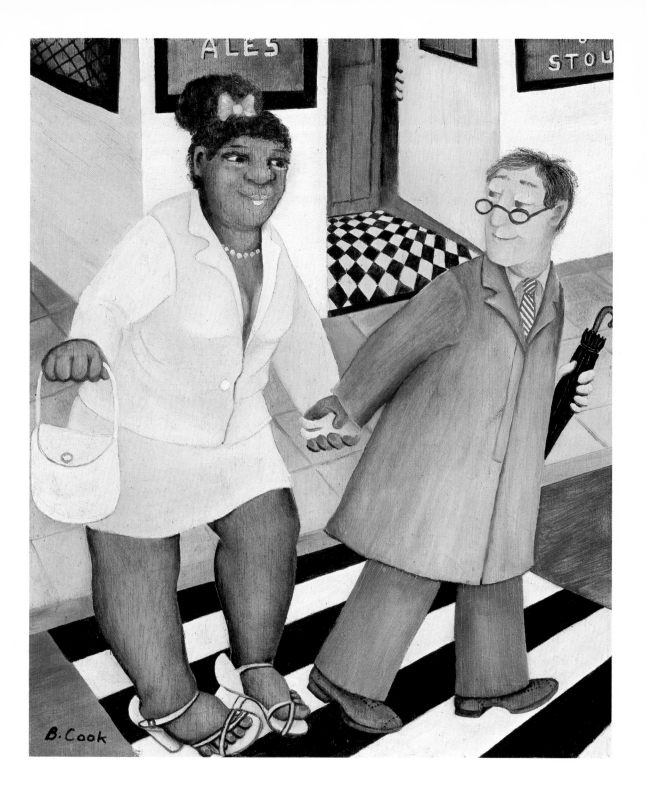

Reading Sunday Papers

This picture started with the bottom and legs; after that, the golden opportunity for me to use some of the favourite headlines I'd accumulated. I like the appearance of newsprint against paint, and spent a couple of very happy hours fitting the papers together. They still make me laugh.

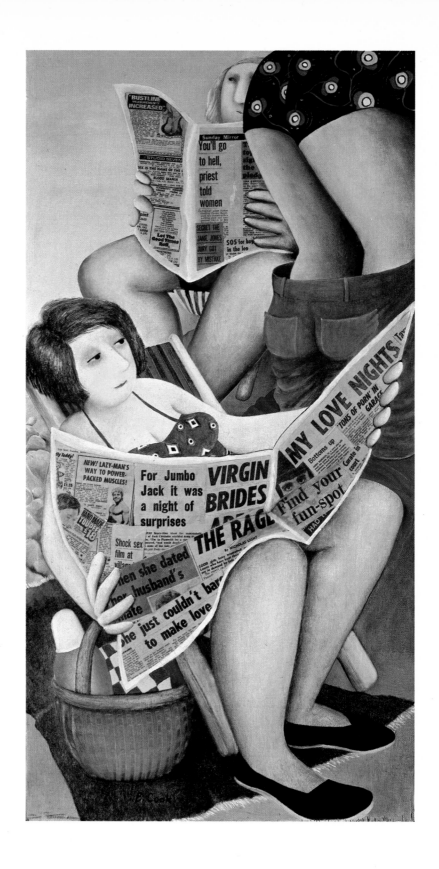

Beside the Seaside

Some people accuse me of exaggerating the figures in
my pictures; they say people aren't really like that.
Believe me, they are. These two ladies walked past
me on the Hoe one morning, and they went into the
picture just as they were. I particularly like painting
big, sturdy women and much admired the large
expanses of bright colour. To give additional
roundness I stuck on pieces of egg box in the
appropriate places.

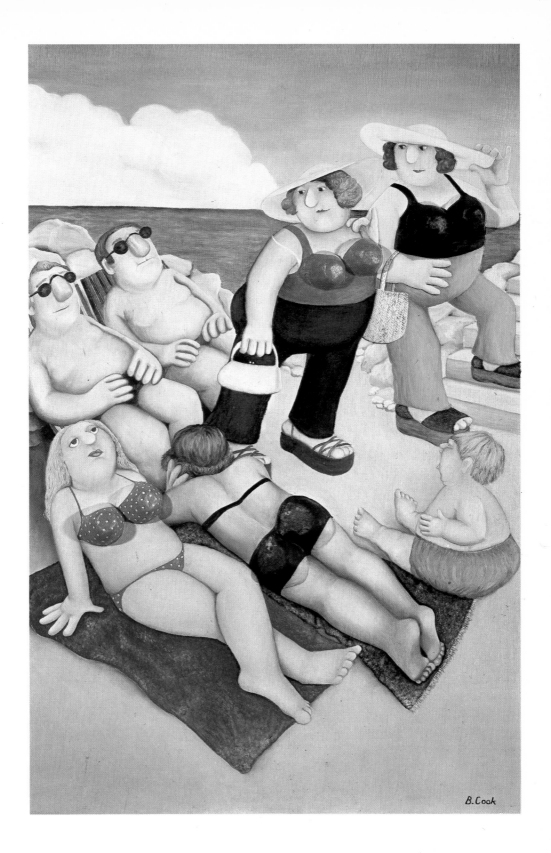

Hips and Chips

This is another figure which you would think must be exaggerated. I must say I couldn't believe my eyes when I saw her in the supermarket, and I'm ashamed to say I followed her all over the shop.

In summer the Hoe is crowded with people eating Kentucky Fried Chicken and dropping the cartons all over the place, and for some time I had thought of painting them; the large lady was just right to complete the picture. My pictures often form like that: an idea can be lurking in my mind for months before I see something else which fits in with it.

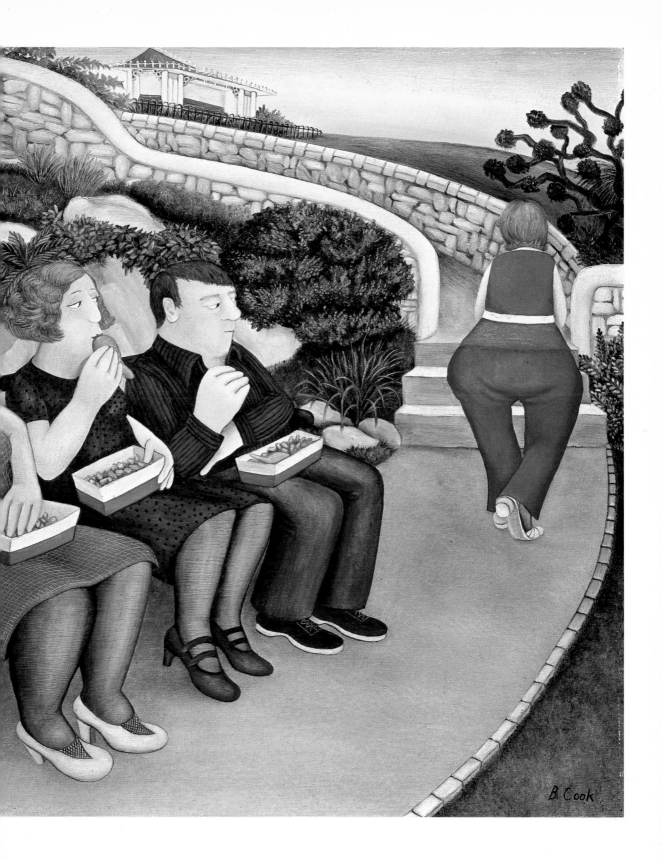

Sabotage

The main thing I'm after in my pictures is to get the design right. I painted this on a circular breadboard, so everything followed in circles, the arm and hand finally ending up like this. Have *you* ever been tempted? After the picture appeared in the *Sunday Times* someone wrote to me: 'I saw your paintings in the paper this morning and I laughed so much I fell out of bed.' It was nice of her, and many others, to write just to say how much pleasure they had given.

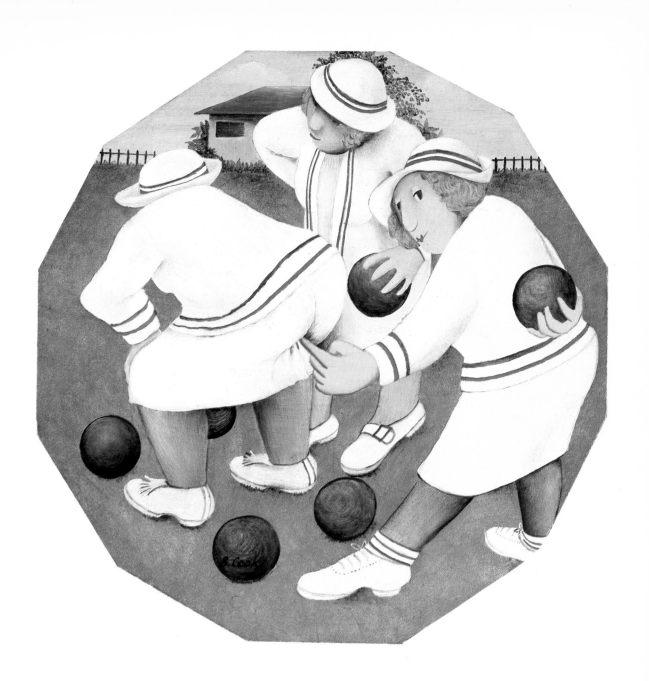

Sailors and Virgins

I saw these sailors on the Hoe last summer, looking absolutely sparkling in their uniforms, and stored them away in my mind until something came along to complete the picture. Then one night we were coming back from the Phoenix in Union Street and saw two girls being followed by some young sailors shouting 'Are you virgins?'. The question grew louder and louder, so did the giggles from the girls, and to my regret we never learned the answer.

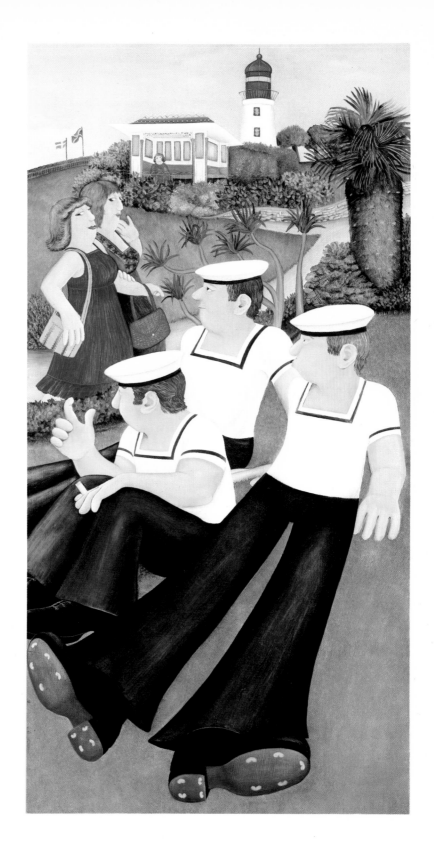

Footballers

I once saw a football picture which was mostly of the
audience and very little of the players, and decided I
would rather have one the other way round. I drew
the figures in white from a match I saw on television,
and as they had so clearly scored a goal I naturally
gave them the colours of our local team – Argyle.
I'm not sure what team the one in front belongs to
but he is very, very dejected.

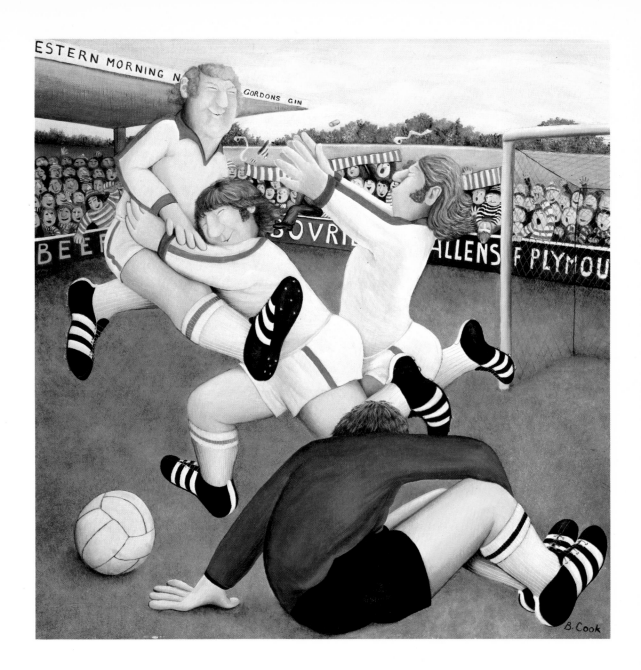

Black Leather

I saw him just outside one of the 'Little Chef' cafés
on the A30. He had just bought his new gear and
looked really smashing in it – and didn't he know it.
I couldn't decide what to do with him for a while
and eventually brought him back to Plymouth and
put him on the Hoe. I copied the motorbike from a
brochure, condensing the engine rather to make it fit
the picture, and painted on canvas which is very
unusual for me.

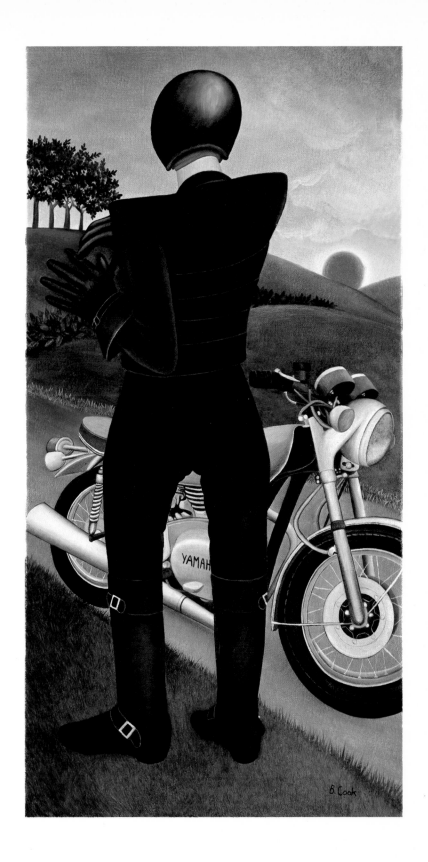

Fish & Chips

I like painting cafés (I like painting
EVERYTHING). I had some difficulty getting a
figure into the front of this one until I remembered a
black man I'd seen in Looe, had a go at fitting him in
here, and was very surprised at the startling result.
So much so that I hastily put it away in a cupboard
and kept it there for quite some time. Several of my
paintings have had this treatment.

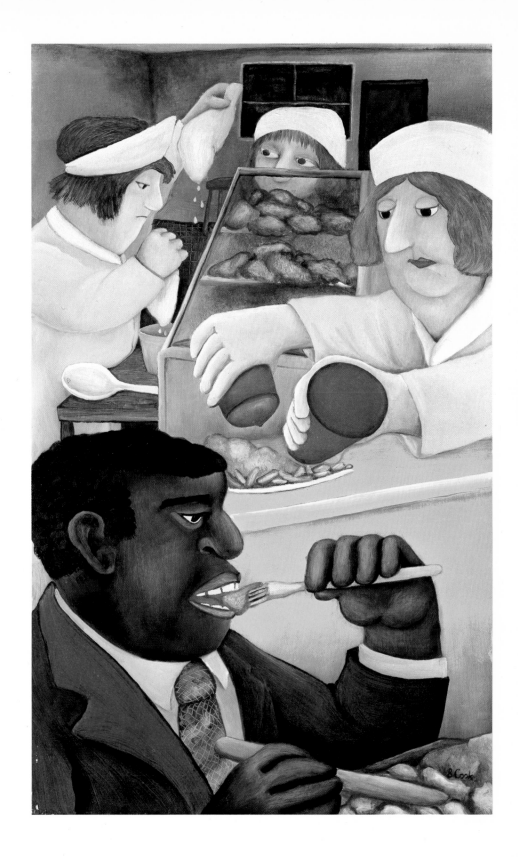

Butchers

This is inside the butchers' shop
early in the morning. I'm always
rather nervous when they're
chopping or sawing the meat, and
became mesmerised by the
bandaged fingers whilst waiting for
my order one day. I got the shape
of the joints from a diagram in the
cookery book but feel I haven't
done justice to the luscious pieces
of beef usually on display there.

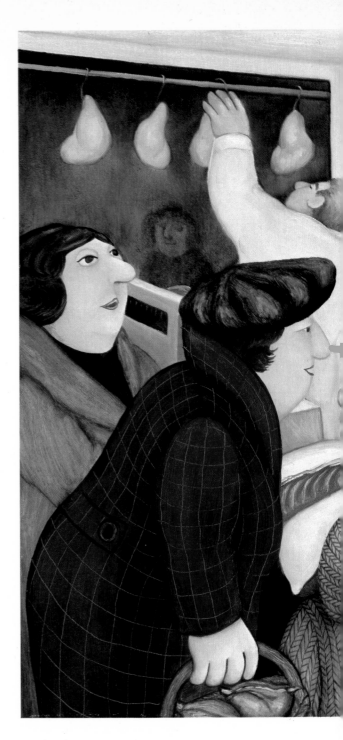

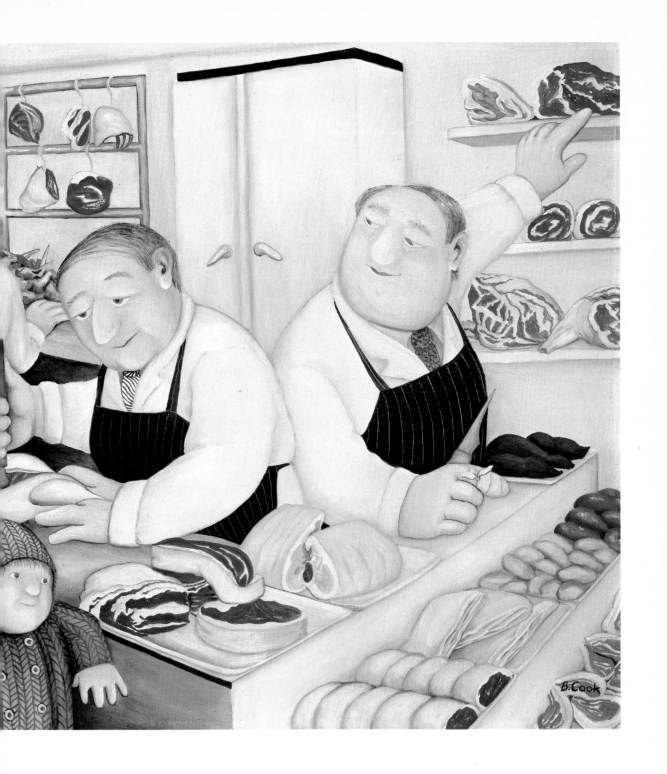

Welcome

When I kept a boarding-house this is exactly how I
felt when I opened the door to new guests, so I
regard it as a self-portrait. I took enormous care over
the see-through blouse and over the hair – red hair is
one of my fetishes – but had difficulty with the teeth:
they turned out rather pointed. I think I was a good
landlady – no restrictions, TV in all the rooms,
cooked breakfast in bed. So far I haven't painted any
of my visitors. One of them was a con-man and went
to prison, much to my amazement. I only realised he
was less than perfect when he departed without
paying for his accommodation.

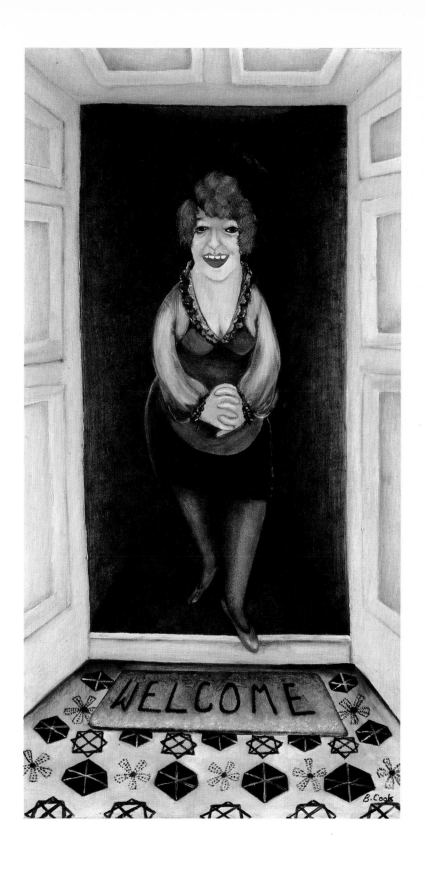

Watching Television

This often happens when we sit watching the TV. John falls asleep and I read a book. Our cats, Cedric and Lottie, come into quite a few of my pictures but Bonzo usually gets missed out because he is the wrong colour – if only he were purple or blue. . . . Poor Bonzo never grew up; I stuffed him full of food when he was young but it didn't make any difference, he's still only half the size I should like him to be.

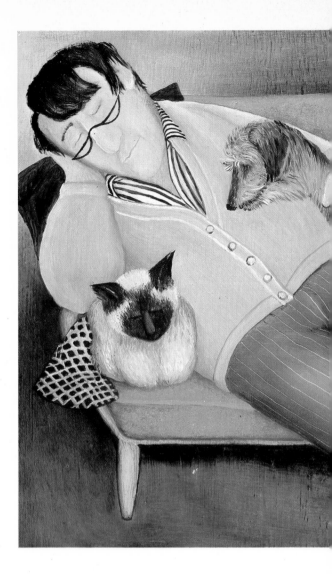

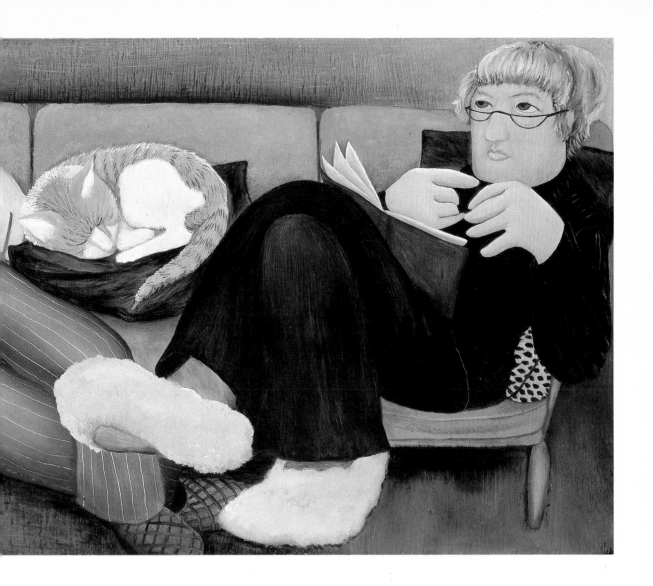

Sunbathing

I never do any housework on sunny days in summer,
nor do Teresa, my daughter-in-law, or Alexa.
Luckily we have a tiny patch of garden at the back of
the house which catches the sun, so we lie there
lazily all day with the animals. We dread that we
might one day be liberated and have to go out to
work instead. I make an effort to get up when John
comes home at lunchtime, not often succeeding
though.

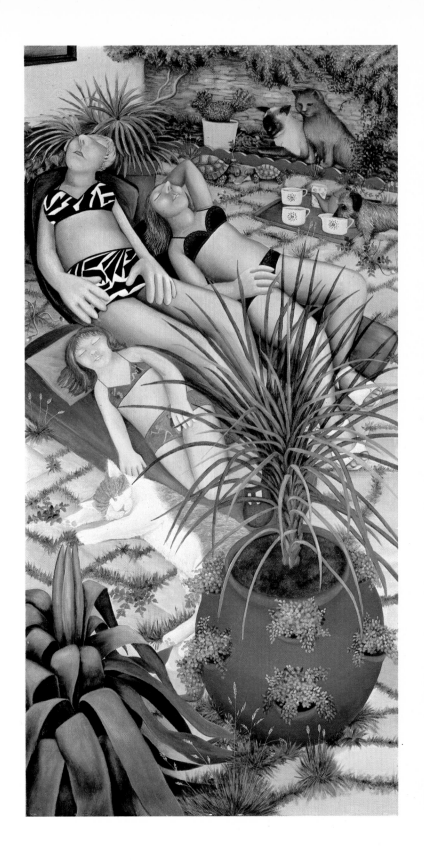

Ladies of the Watchtower

I don't often paint from sheer malice, but this was an exception. I grew to hate these two Jehovah's Witness campaigners who were always coming to the door and pestering me. After several reasonably polite requests to them not to call on me, I once again found them there – side by side, leaflets extended. Slamming the door I vowed 'I'll get you' . . . and I did!

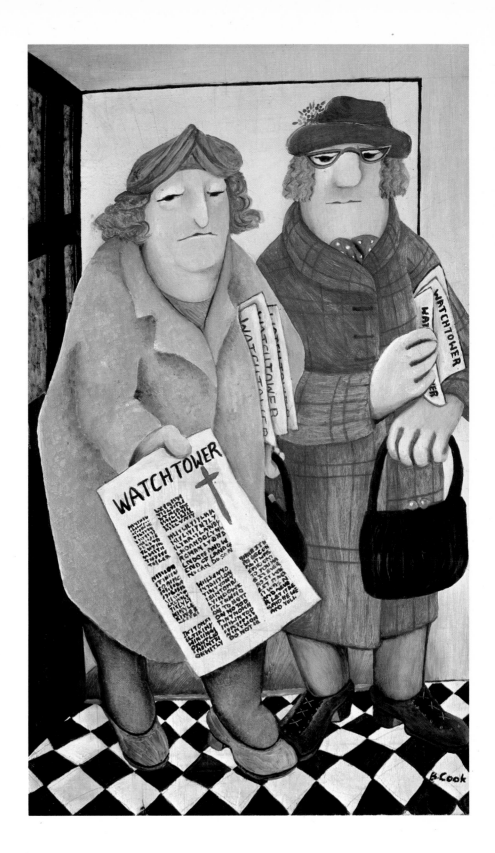

Anyone for a Whipping?

This picture was specially commissioned by John for
his birthday. He said he wanted a great big nude –
with very naughty underwear, really outrageous.
And for good measure I added the whip and placed
her against a bead curtain I'm very fond of. Having
left myself short of room, she had to have little
weeny legs so I could give her some nice black high-
heeled boots.

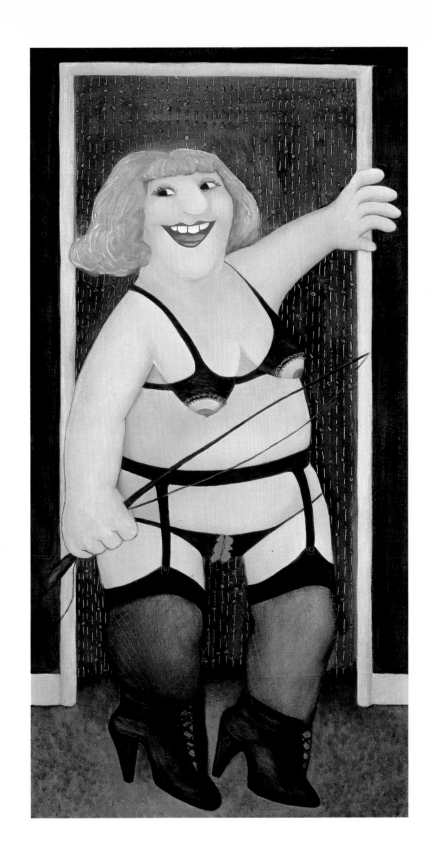

Teddy Boy

John saw this Teddy Boy walking down Charing
Cross Road, very proud of his appearance, and
pointed him out to me. On the way back to the hotel
we stopped at the tobacco kiosk nearby to read the
cards – plenty of French lessons as usual – to find
out if any good ones had been added and decided to
copy them all down. This took rather a long time;
when we had finished we turned round to find that a
small crowd had gathered behind us, and we scuttled
off furtively.

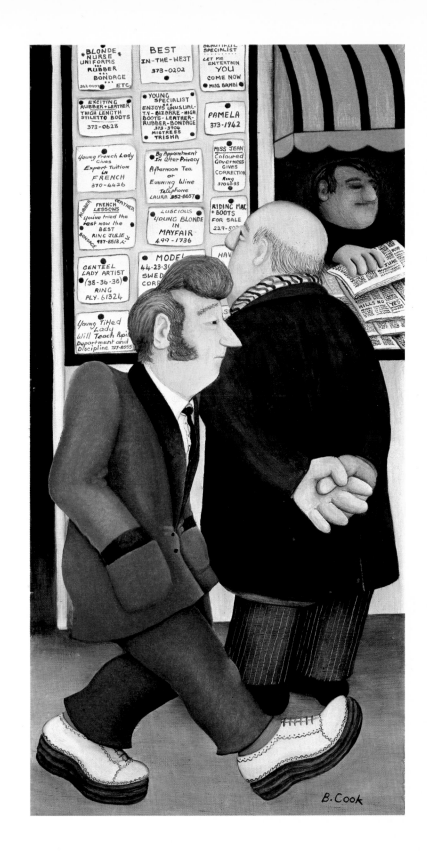

Togetherness

This picture contains some of my favourite subjects: large hands and lots of them, newspaper headlines, and a dirty old man. I don't know if there are many of them around now, when I was young there used to be plenty in the tube trains. I have painted him one way or another at least three times now, always making the girls suitably indignant!

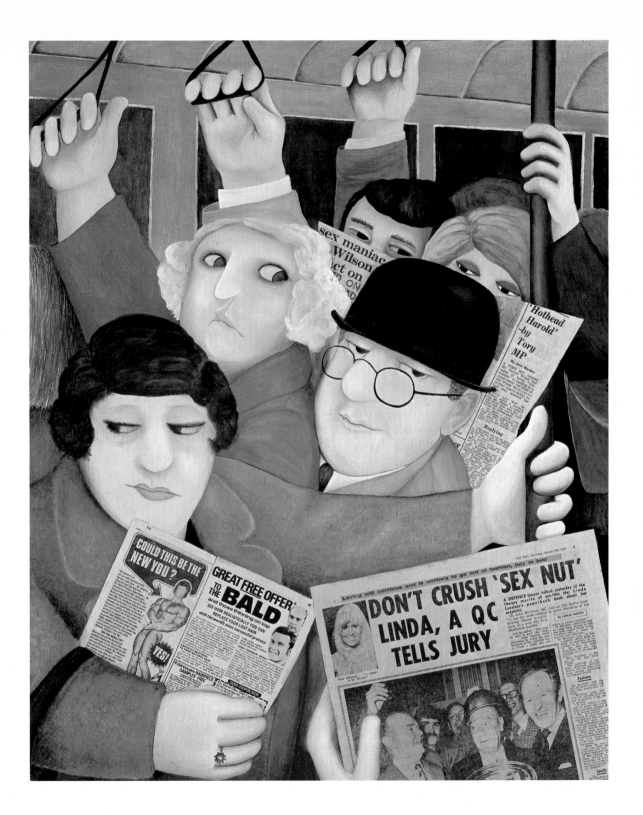

Goodbye Elvis

At home I have a picture of a
Victorian deathbed scene, with all
the family mournfully sitting round
the bedside, and I was working on a
pair to go with it: the dead man up
in heaven looking down on his
grief-stricken relations. Then Elvis
died and I found myself painting
him into the picture. Elvis was one
of my heroes and I was very sad
when he died, but also astonished at
the sight of all those ageing rockers
in their leathers sobbing at the
memorial services; I felt they'd
finish the picture off nicely.

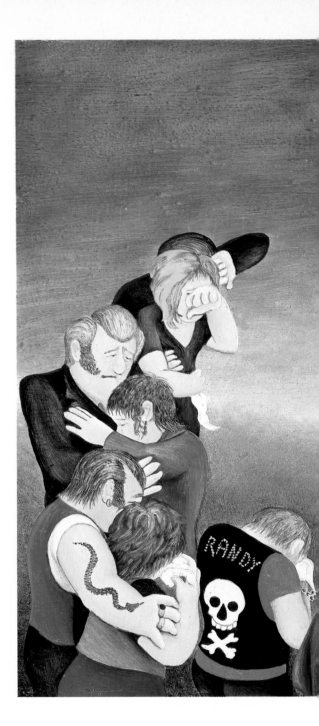

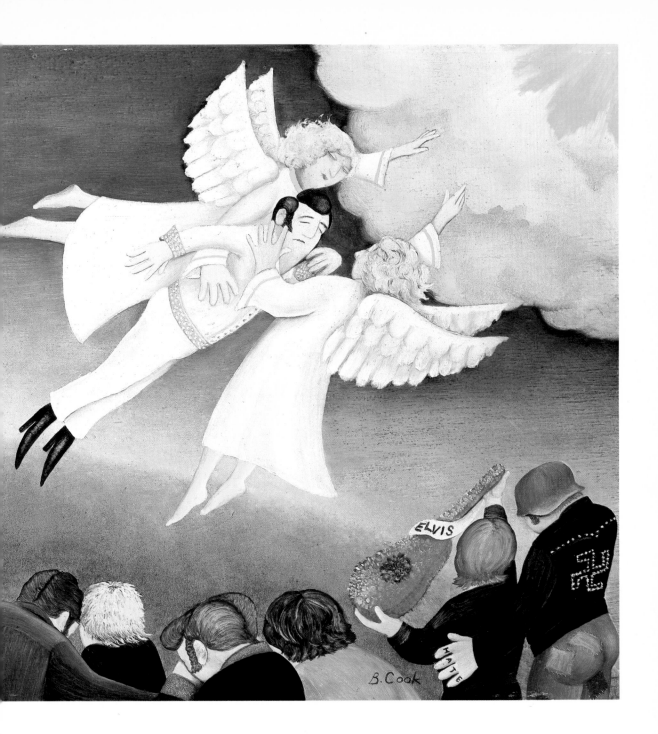

Pianistes

I'm not at all musical but love watching people play musical instruments. Crossed hands have always seemed to me the very height of expertise in a pianist, and for the first time I indulged my ginger curl fetish in this picture – painted many years ago. I've always felt the painting would make an ideal postage stamp and hope a ginger-curled duet-playing member of H.M. Government will see this and agree with me.

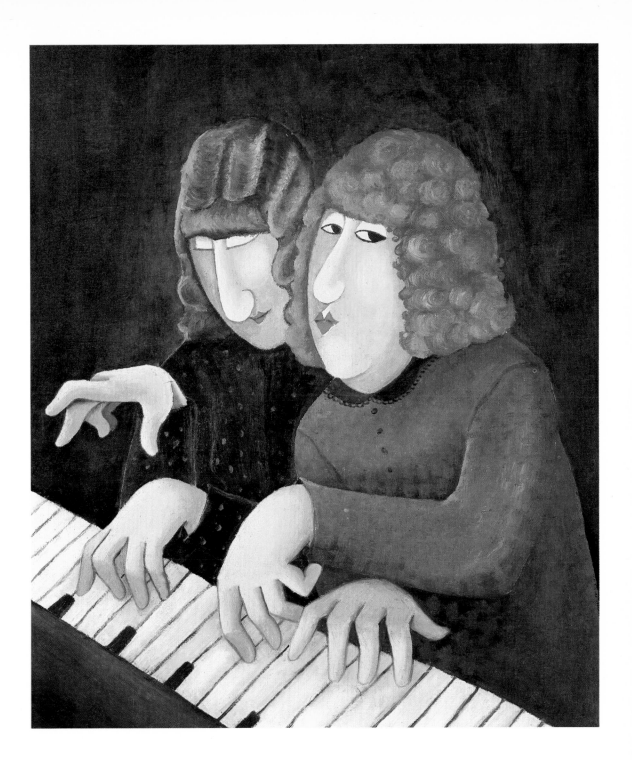

Come Dancing

I'm always excited when I start
painting, it seems magical when a
picture appears from a blank board.
The first pig's face caused me such a fit
of hysteria that John had to help me
back to the paints. I've always liked
pigs since we kept them many years
ago, and used a picture book belonging
to my grand-daughter Alexa to find
out how their trotters should be. This
picture is inspired by *Come Dancing*: I
love watching the formation teams,
when they all come in together
perfectly in time.

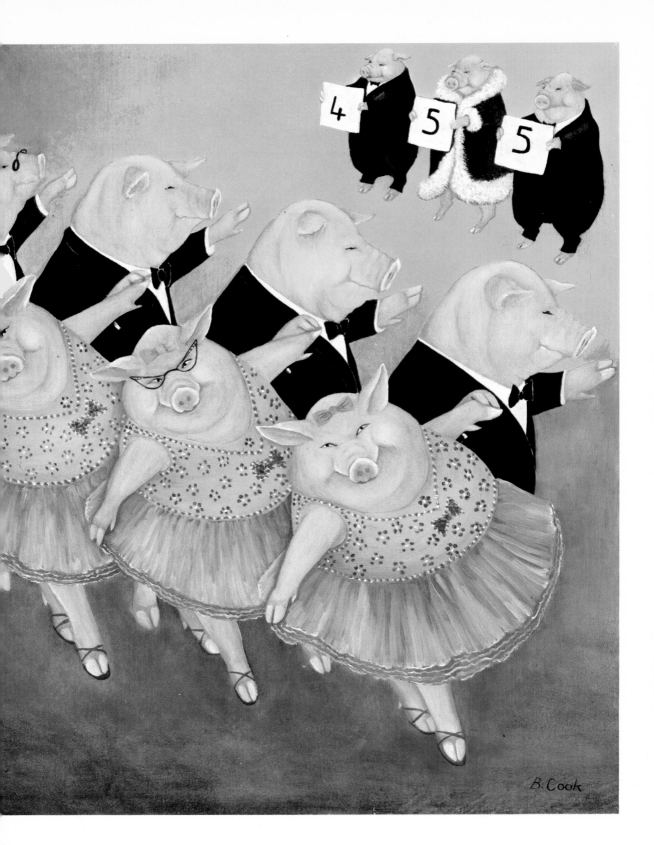

Vultures

This is one of the first big pictures I painted. Intended as a large, exotic countryside scene it was only after painting the sky and tree I realised how difficult it was going to be. After some unsuccessful attempts at filling in the lower half with luxuriant plants and vegetation I gave in and used one of my great favourites – *Come Dancing*. One man is very cleverly managing to dance with no legs, but I overlooked this in view of the fact that I had actually succeeded in covering such a large expanse with paint.

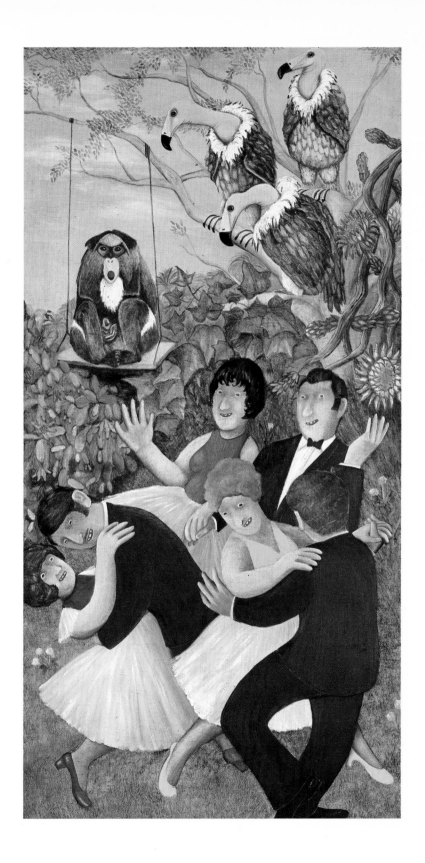

Wedding Photograph

For some time I had been planning to paint a really fat family and when John showed me a wedding photo in the local paper I thought perhaps I could base it on this. In my efforts I fear I have rather distorted matters, and I've been told since that this family are doing *everything* that a photographer dreads.

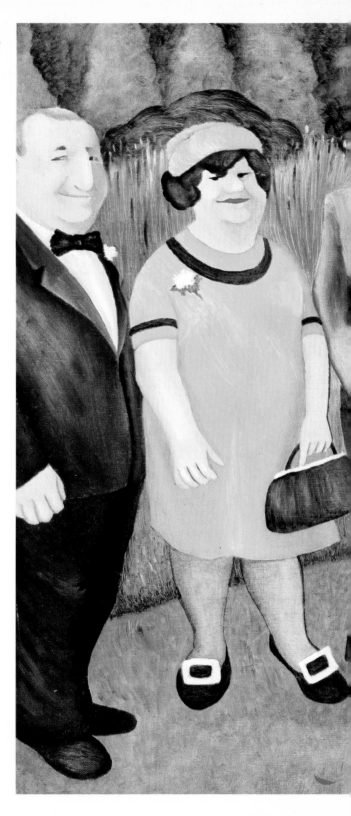

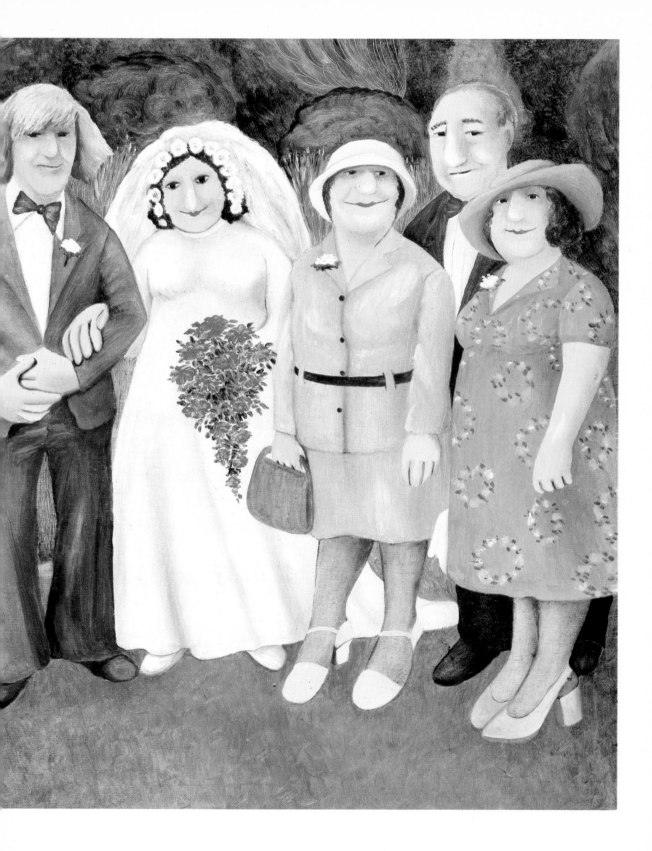

Queen Dancing

I am a great admirer of the Queen and thought it would be nice to do a special Jubilee picture of the Royal Family sitting in one of the lovely municipal shelters on the Hoe. I collected all the Jubilee pictures from the papers, but just couldn't get the composition right. Then I saw an old engraving of Elizabeth I dancing with her courtiers and being swept into the air by one of them. It was just what I needed. I felt the picture warranted a really *royal* frame, and made this by sticking plastic flowers onto the wood and spraying it silver; or rather, Teresa, John and Alexa did the sticking.

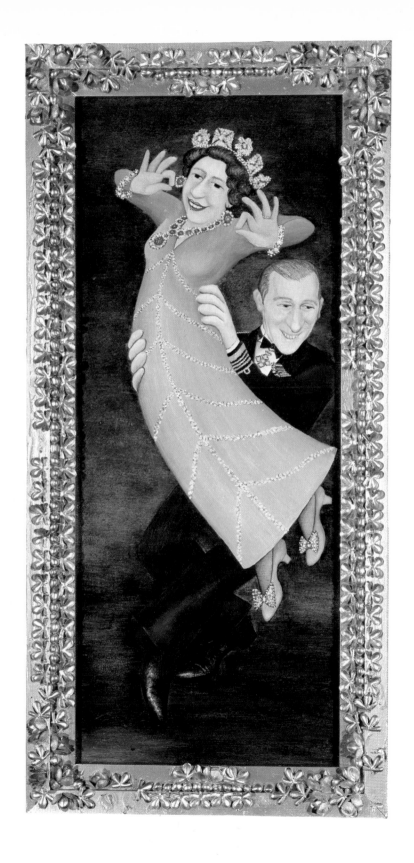

Acknowledgements

The following have kindly given permission for their paintings to be reproduced:

Footballers, Roger Wilbraham; *Sylvia* and *Reading Sunday Papers*, Tony Martin; *Handel & Liszt*, Phyllis and Joe Quick; *Hips and Chips*, Alan Gatward; *Sabotage*, Jane King; *Butchers*, Alan Cluer; *Welcome*, Nicholas Mason; *Ladies of the Watchtower*, Ian Gordon; *Togetherness*, Dr Sidney Gottlieb; *Come Dancing*, N. C. Granby; *Wedding Photograph*, Bernard Samuels; *Queen Dancing*, A. Schiller; *Self Portrait*, Lionel Levy; *Black Leather*, Michael Barnfather; *Sailors and Virgins*, Jan Pieńkowski.

Photography: Rodney Todd-White & Son Ltd.
Design: Ian Craig.

The publishers are grateful for the co-operation of Portal Gallery Ltd, London, who represent Beryl Cook.

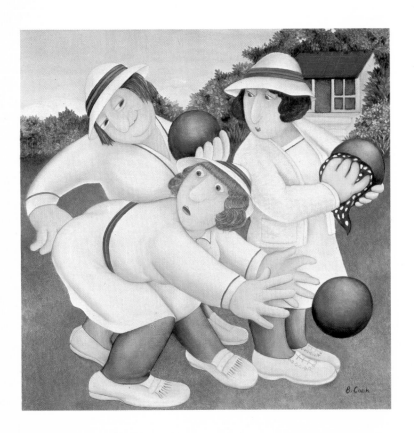